PICASSO
THE LATE DRAWINGS

With an essay by Jeffrey Hoffeld

Hirschl & Adler Galleries, Inc.

Harry N. Abrams, Inc., Publishers, New York

ACKNOWLEDGMENTS

This publication accompanies the exhibition of late drawings of Picasso at Hirschl & Adler Galleries, from January 16 to February 27, 1988.

Colleagues in Europe and the United States generously assisted in the gathering of this varied sampling of Picasso's late drawings. In this regard, special thanks are due to James Kirkman, Leslie Waddington, Thomas Lighton, and Thomas Gibson in London; to Galeries Beyeler in Basel, and Rosengart in Lucerne, and to Heinz Berggruen in Geneva; to Jan Krugier and Diane Upright in Geneva and New York; and to Eleanor and Daniel Saidenberg in New York.

Jeffrey Berman of Waddington Graphics in London kindly introduced me to Picasso's etchings for *Célestine*. In the text that follows, all quotations from the original Spanish of *Celestina* are taken from the Mabbe-Bentley translation, cited in the bibliography.

At Hirschl & Adler, Stuart Feld, President, provided continuing support and encouragement for this project. Donald McKinney and Mathias Rastorfer aided in the search for drawings, while Mary Sheridan and Richard Sica organized the actual physical gathering worldwide of the works for exhibition.

Meredith Ward prepared the catalogue entries for the drawings, as well as the bibliography, at the back of the book, of writings that are of particular relevance to the late work.

Cynthia Pittel saw the manuscript through its many phases, and it benefited immeasurably from the criticism and editing of Gypsy da Silva, Wendy Muto, and Carol Fein.

Marcus Ratliff and Lawrence Sunden brought their special talents to bear in transforming manuscript and photographs into a book worthy of its subject.

© 1988 Hirschl & Adler Galleries, Inc.
Library of Congress Catalog Number: 87-83280
ISBN: 0-915057-20-4 Paper
ISBN: 0-8109-1497-2 Cloth

Picasso is an artist who will use up generations of critics and commentators.

—James R. Mellow

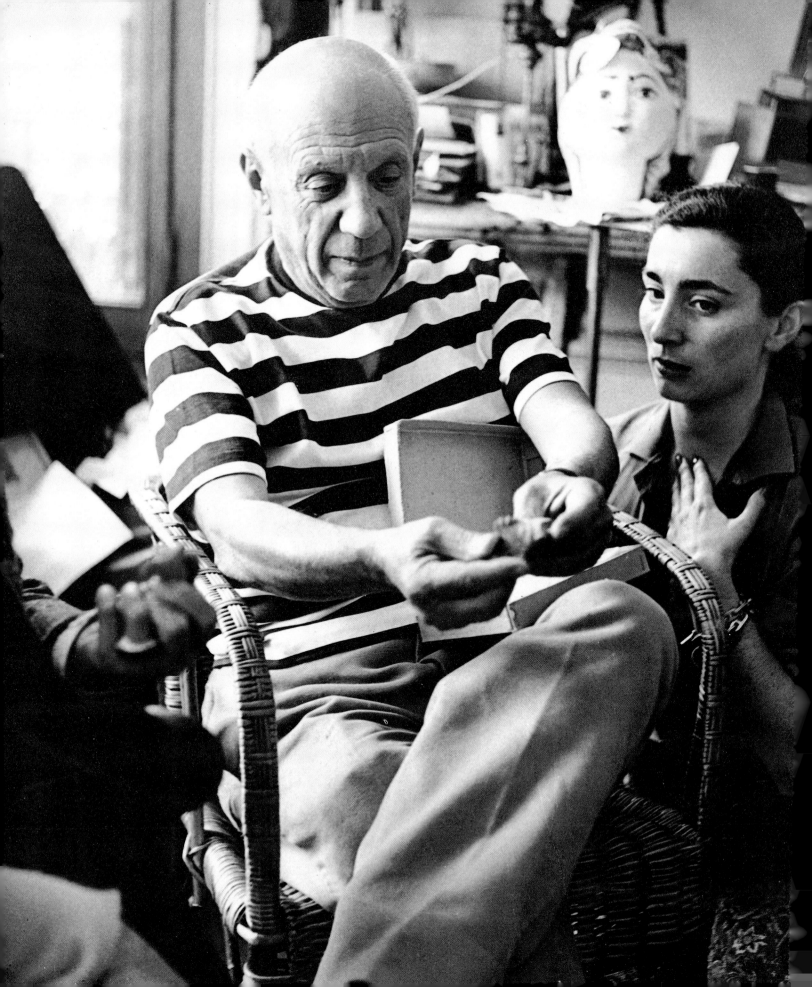

Picasso's Endgame

In Memory of Victor W. Ganz

L IKE A PATRIARCH of the Old Testament, Picasso was fruitful in his old age. However, his late work (defined here by the period between 1960 and his death, at age ninety-two, in 1973) has been largely ignored. Even recent surveys of this Promethean career continue to play down the accomplishments of Picasso's last years. In 1972, when Leo Steinberg published his study of the 1954–55 cycle of paintings, *The Women of Algiers*, he was one of the first to venture, like an explorer in outer space, into the seemingly off-limits realm of the Spanish master's twilight years. Since that time, thorough and illuminating essays by Gert Schiff, as well as exhibitions at The Pace Gallery, the Guggenheim Museum, and the Kunstmuseum in Basel have brought to light the richness of the artist's final years, confirming the importance of the late work, and effecting broadened appreciation and lively commercial support for Picasso's old age style.

Picasso's last works have been more enthusiastically embraced in America than anywhere else. Their recentness and obvious correspondences with abstract expressionism make them especially attractive to admirers of contemporary art. Partisans of Picasso's early career, with its more apparent embodiments of his concept of a work of art as the sum of revisions and destructions and further revisions, however, see the late paintings as slapdash and unresolved. Although there are equally clear examples in the late period of works with complex subjects that have been heavily worked and reworked, the key monuments of Picasso's last years are, nonetheless, frequently omitted from the official history of his art. In spite of all claims that it is the style of the late work which provokes criticism, it is clear that the provocative content of Picasso's late work, its open display of sexual feeling, what Emily Genauer called its utter obsession with sex, has made critics and collectors resist the art of these final years. Embarrassment has set apart the late sexy work from consideration alongside the more orthodox canon of the early years. Refusing to lie down, unsubmissive, Picasso remained unruly and artistically unpredictable. Serious illness, surgery and recovery, during 1965 and 1966, could not do him in, although the relatively small number of works he made in that period isolate these years from the

otherwise astonishing productivity of his late years. Defeats that would undo any man in old age committed Picasso to his art—the lifeline and rejuvenating tonic of the old master.

> *Chaque journée commence pour toi*
> *comme une érection puissante, une ardente*
> *pointe de lance tournée contre le soleil qui monte.*
> *C'est Priape qui continue d'enflammer*
> *l'invention de tes grâces et de tes monstres.*
>
> > —RAFAEL ALBERTI, in his devotional poetry
> > about Picasso's late work

> *(Each day begins for you*
> *like a powerful erection, a heated*
> *spear point turned against the rising sun.*
> *It is Priapus who continues to ignite*
> *the invention of your graces and your monsters.)*

IN HIS EIGHTIES, Picasso was a creature of the 1960s. He was politically astute and sexually aware. Stirred by world events, specifically the Cuban missile crisis of 1962 and its threat to world peace, he painted the powerful *Rape of the Sabines*, continuing his lifelong concern for humanity and the sensitivity in his work to events of the day that previously inspired the major paintings *Guernica*, *The Charnel House*, and *Massacre in Korea*. Picasso's late work suggests many of the ideals of a flower child of the '6os, of the emerging sexual revolution of the time. In his art, he is a voluptuary, hedonist worshipper of flesh and orgiastic tumble.

The reputation of Picasso's late work has suffered from the general reassessment of the '6os and its attitudes toward women. Condemnation of the cigar-sucking Castroite guerrilla in army fatigues, hypocritical exploiter of women for the cause of "the revolution," has made its way into the critical evaluation of Picasso's late work. Branded as woman-hater, the scourge of women, and defiler of their sacred image, Picasso is criticized

for his spread-eagle women and his amatory musings. The octogenarian bad boy who dared to marry a young woman and make dirty pictures in his old age is resented, in the end, for his virility. Were the work of his old age flaccid and impoverished, the uncontrolled spittle, the senile cursing, and the ludicrous flashing of an artist in his dotage, it would less easily give rise to such criticism. Had the drawings been distributed in brown wrappers, studied in the privacy of the boudoir and the john, their disturbing voice might have been kept to a whisper. But these late works have the full power and control of Picasso behind them.

Disporting and cavorting are not the only subjects of the late drawings. In fact, the drawings offer a richness of ideas and iconography for which no complete lexicon is likely to exist. These seemingly desultory sheets, over which Picasso's mind appears to run in free association, nonetheless have a controlled program. The unabashedly first-person, diarylike entries, compulsively dated and frequently serialized, probably once held together more tightly, like a vast confessional epic novel. We are at a disadvantage, left to consider them now as individual sheets without the benefit of viewing the drawings in their original sequences as an organic whole. As we turn the pages of the Zervos volumes for Picasso's last years, we can begin to reassemble and enjoy their original integrity. The disembodied sheets that come to us now from all directions are like illuminated manuscript pages. Defying study as single leaves, as if they were easel paintings isolated from each other, they should be seen instead as cycles of illustrations bound together as complete books. In this way, the liturgy of Picasso's picture cycles, their ceremonial denouement, can be appreciated without disruption. Here and there we pick out familiar characters and recurring themes, appearing and reappearing within gatherings—sometimes only briefly, making their appearance in a specific month, for one week, or for just a day; occasionally motifs are carried over from year to year, as elements of a continuing epic drama. Narrative development, now choppy or altogether discordant in the disjointed sheets, must have been fuller and more satisfying in its origins, as Picasso staged events and directed characters with his unique sense of timing. In his printmaking of the same period, we can recapture the rule of order that Picasso may have imposed on his drawings: the shaping and presentation of minor characters and heroic figures, the richness of subjects and coherence of themes that integrate and provide continuity for the flurry of pages from the last years.

Picasso's erudition was extraordinary; his ability to assimilate, recall, and put to use information is staggering. The drawings reveal many of the visual sources that played upon his mind toward the end of his life. Goya, Matisse, Manet, Rembrandt, Velasquez, Delacroix, Ingres, Courbet, Rousseau, and Van Gogh are present. There are subtle persuasions, too, from classical sculpture, the erotic prints of Utamaro, the sexy drawings from Rodin's old age, and Degas' lewd monotypes. Picasso said there is no past or future in art. And clearly there was no past as such for him in his own art. Nor were there rigid boundaries to artificially circumscribe the concerns of the late work. As in his youth and middle years, Picasso's concerns in his last years cut across the work, enjoying free range from medium to medium. Prints and drawings of the late period are particularly close relatives. Drawings were often made directly over prints. Images embedded in dark inks, apparitional traces of people within people—the palimpsestlike layering of information in the late drawings—are a distinctive feature of this work. Together, prints and drawings provided ammunition for paintings; themes, personae and elements of style found within the encyclopedic depth of the works on paper are dramatically compressed and cavalierly abbreviated on canvas. The sheetmetal sculptures of the last years, made monumental by their amusing folds and accordionated white spaces, are echoed in drawings, where figures, leveraging themselves, take over their spaces, assert their scale, and are finally sentenced to captivity, like Michelangelo's sculpture within architecture, struggling against confinement.

J'imagine Picasso, tel que le "vieillard fou de dessins" s'est dépeint
dans son Traité du coloris: *un pinceau dans la bouche, un dans*
chaque main, un à chaque pied, dans une incessante frénésie
picturale . . .

 —BRASSAÏ, in his *Conversations avec Picasso*

(I think of Picasso as "the old fool of drawing" depicted in his Traité
du coloris: *a brush in his mouth, one in each hand, one at each foot,*
in an incessant frenzy of picture-making.)

BEYOND THE MOMENTARY influences of other artists on the work of Picasso's last years, there is an enduring presence in the work of Picasso's own youth. Old man and young boy appear side by side, just as residues of Picasso's earlier styles are joined in the late drawings to those of his old age. In the end, as the Andalusian master set about summing up his years, reviewing his long career and its monuments, seeing his life pass before him, his past was uniquely brought back to him. Large new quarters in Notre Dame de Vie, in the quiet village of Mougins, provided Picasso with an opportunity in his last decade to assemble around him a panorama of works from the history of his own art. As Pierre Daix describes it, at Mougins Picasso colonized his own work. His art, and some of what he collected of the work of others, stood before him. The range of objects, of which we have glimpses in the marvelous photographs by Edward Quinn of the Mougins studio, enriched the sources available to Picasso in these exciting last years. Cubist sculptures stand side by side with full-size casts of Michelangelo's *Slaves*. Ceramics, drawings, and paintings commingle on work tables. Disparate periods of paintings flow together, physically overlapping in file-card-like stacks. Renewed access to his own past provides a unique mnemonic device for the aging genius, resulting in frequent quotations from the early work in the late drawings. A new fluency emerges, including an apparent bias in the late drawings toward works from the '30s. The famous Picasso surrogate of the '30s, the Minotaur, mighty lover—half-man, half-bull—of Ovid's *Ars amatoria*, ravishes women in much the same way as women are taken in the late work.

Can it be that the drawings get stronger and stronger as Picasso got older, achieving real greatness in a final nineties crescendo? At ninety Picasso had still not exhausted his fascination with Delacroix's sultans and his supple Algerian women. These characters enjoy a special place in the works of 1969 to 1971.

Jacqueline devient tous les personnages. Elle prend la place de tous les modèles de tous les peintres sur toutes les toiles. Tous les portraits lui ressemblent, même s'ils ne se ressemblent pas entre eux. Toutes les têtes sont la sienne, et il y en a mille différentes. Tous les yeux sont noirs,

tous les seins sont ronds, il pleut des Jacqueline dans toute la maison,
où qu'on se tourne, elle vous regard.

—HÉLÈNE PARMELIN, in *Picasso Dit . . .*

(Jacqueline becomes all of the characters. She takes the place of
all of the models in all of the paintings on all of the canvases. All the
portraits resemble her, even if they don't resemble each other. All the
heads are hers, and there are a thousand different ones. All the eyes
are black, all the breasts are round. Jacqueline permeates the house;
wherever you turn she looks at you.)

IN THE GARRULOUS DRAWINGS of his last years, we are easily taken into Picasso's confidence. The workings of his mind and the sources of his inspiration are more freely, almost confessionally, shared. Two Dutch masters, Rembrandt and Van Gogh, occupy nearly polar positions within the drawings. Rembrandt, sometime alter-ego for the aged Spaniard, makes frequent personal appearances in these final hours. The Northerner's own work was a frequent source of inspiration for his Southern protégé, particularly in the drawings made in 1967 and 1968; musketeers, reclining nudes and genre pictures record Picasso's special admiration for Rembrandt. Picasso's muse and model of the last years, Jacqueline, enjoys, like Saskia, a central place in the imagery of the late work. Even the incandescent light of the '60s drawings was inspired by Rembrandt, as were the dusky inks, wine-dark like Homer's Aegean, spread out as mysterious veils across so many of the late drawings, in much the same way that a moody, chiaroscuro darkness envelops Rembrandt's late work.

If Rembrandt represented the dignity of the artist in old age, the rewards of confidence and the ultimate payoff for the hard-earned virtuoso style, then the life and time of Van Gogh stood for the harsh realities of decline. Vincent's tortured face, stubbled and gaunt, often looks out from behind Picasso's late self-portraits. Haunted eyes set deep in skeletal sockets face the horrifying realization of death's approach.

If Picasso was world weary as he approached ninety-two, he generally keeps it from us. We have to search hard, bearing down with all the powers of our hermeneutics, to uncover any signs of weakening spirit and diminished energy in the late drawings. This forceful work is an aggressive protest, a Job-like outcry against the inevitable. With only intimations of mortality, the ferocity of the drawings depreciates the grip of death on their maker with a vigor and lustiness that deny death its place.

Many of the late works recall the sculptural programs of antique sarcophagi. Life, celebrated in Dionysiac revelry, denies death. Mortal meets god and enjoys unfettered pleasure. Consenting adults party; there are costume balls and orgies staged to console the soon-to-be departed, as well as to comfort bereaved survivors. In this, his last will and testament, Picasso leaves behind for Jacqueline, and his world of admirers, memories of fun-loving Picasso, reveling in pleasure, turned on by sex, fascinated by his young wife, and bursting with the sap of sexual desire.

> *An aged man is but a paltry thing,*
> *A tattered coat upon a stick, unless*
> *Soul clap its hands and sing, and louder sing*
> *For every tatter in its mortal dress,*
> *Nor is there singing school but studying*
> *Monuments of its own magnificence . . .*
>
> —WILLIAM BUTLER YEATS
> from "Sailing to Byzantium"

A PRIMORDIAL PAST, an age of dignity and solemnity, is brought to life in the late drawings. Young and old, male and female, naked and clothed ceremonially gather. Fresh and innocent regardless of age, their meeting is timeless; the place, other-worldly, nearly airless. The setting is distinctly pre-industrial. The mood is more nomadic than agrarian. Although landscape is not an important component of the late work, there are shepherds;

flutists entertain; here, satyrs exist and cherubic youths enjoy free play. A mythic past is evoked, one derived from a special brand of fiction that came down to Picasso from the ancients. He knew this place well from Greco-Roman and Renaissance art; he read about it in the classics of Ovid and Virgil. This locale made its debut earlier in his life in the art of his "classical" period of the early twenties. The polymorphous perversity, the exhausting sexual escapades, men like gods and gods like men, are all to be found here, too. This is Arcadia, Picasso's '60s version of the ancients' utopian dreamland. The place to get back to. A zone outside harsh reality, a sanctuary of idyllic bliss, reserved for pathos, play and good feeling.

It is only in occasional self-portraits, made in his nineties, that we witness Picasso's sense of his own decline, the palpable terror of his old age and ultimate demise. In their allusions to the agony of Van Gogh's life, these few works present a more naked avowal of Picasso's own unraveling. Elsewhere in the work there is only circumstantial evidence of the deteriorating old man behind the artmaking: perhaps in the implied passivity of the many scenes looked in upon by dissociated outsiders, pathetic voyeurs who gawk rather than partake; perhaps in the numbers of recumbent figures, male and female, like the men and women who recline on the lids of antique coffins; perhaps in the predominance of horizontality itself in the late work—of lying down, of beds, of sleep; perhaps, too, in these horizontal sheets of paper themselves (far outnumbering vertical formats in the late drawings) that accent and reinforce, in frieze-like compositions, the mood of containment and repose that may have contributed to these works.

Lorsque je vois un ami, mon premier geste est de chercher dans ma poche un paquet de gauloises pour lui en offrir une, comme autrefois. Or je sais très bien que nous ne fumons plus. L'âge a beau nous obliger à renoncer à certaines choses, le désir reste. C'est pareil pour l'amour. On ne le fait plus, mais le désir demeure. On met la main à la poche.

—PICASSO, speaking with his
biographer-friend, Pierre Cabanne

*(Whenever I meet a friend, my first reaction is to search in my pocket
for a pack of Gauloises, in order to offer him one, just as I always used
to. Even though I know very well that neither of us smokes anymore.
In vain, old age forces us to give up some things; the desire remains.
It's the same with love. We can't make love anymore, but the desire is
still there. I still reach into my pocket.)*

PICASSO IS BOLDLY DEVOTIONAL and adoring of women in the drawings of his
last years. His obsessional gynecology, expressed in nearly clinical illustrations, is ux-
orious. His concern for vulva and womb echoes the fascination of the early church fathers
for the wounds of Christ: heraldic display to the faithful and the finger-testing of Thomas,
doubting, as he seeks verification of the true identity of the born-again loved one. Part sad
remembrance of things past, part idolatrous preoccupation with the body of his young wife,
many of the drawings have the character of devotional images: mantric diagrams of
flesh—womb—vagina are the iconography of a nearly sacred quest for re-entry, a search for
shelter and warmth, and a longing for rebirth. Contortionist sexual gymnastics, if only
portrayed rather than actually lived, vicariously restore confidence, relieve despair, and
provide recollected moments of orgasmic oblivion.

Picasso's obsession with sex in the late work probably had an apotropaic function for
the old master: an image of sexual vitality serves as an amulet against death, that clear
water, as he called it in his youth. The drawings restore a sense of well-being and vigor with
the promise of an Arcadian restoration of youthfulness and vitality—the consoling image
of a realm of infantile feeling, a refuge of play and pathos.

If death has a place in Picasso's late work, even if it is one that merely peeks out from
behind masks and curtains, looks out from beneath beds, lurks on the edges, it is no
wonder. Although he enjoyed the protection of his wife, Jacqueline (she was criticized, in
fact, for over-protecting Picasso, for shutting out the world and cutting him off from his
friends and children), Picasso could not, finally, be saved from the harsh realities outside
the walls of Notre Dame de Vie. The world continued to come to him from occasional
visitors and telephone conversations, newspapers and, especially, television. There was no
end of bad news, and death was certainly no stranger in these last years. Just like any other

senior citizen, Picasso lived to experience in these years the deaths of many who were especially dear to him—Braque, Cocteau, Sabartés, and Christian and Yvonne Zervos.

Picasso's world was shrinking as he was shrinking from the world. His retreat is evident in the work itself. Picasso's fascination in the late work with musketeers, obviously derived from Rembrandt and the Baroque masters, may also have its origins in the uniquely Spanish linguistic connection, pointed out by Schiff and others, that links the word *mosquetero* with outsider, or "odd man out."

> *For now I am a decayed creature, withered and full of wrinkles, and nobody will look at me. Yet my mind is still the same: I want rather ability than desire. Fall to your flag, my masters, kiss and clip. As for me, I have nothing else to do but to look on and please mine eye. It is some comfort to me yet to be a spectator of your sports.*
>
> —CELESTINA, THE SPANISH BAWD
> from Fernando de Rojas' *Celestina*

THE LATE DRAWINGS provide abundant evidence of the outsider consciousness that may then have dominated Picasso's thinking. Characters young and old spy on the central action. Bearded old men take in peep shows of kamasutrian lovers. A young artist ravishes his model as a bug-eyed old man looks on. The very young gawk at what they cannot know. Men of all kinds—celibate monks, old men, eunuchlike attendants at court, debauched warriors, men with big swords, tall candles, rigid limbs, and vacant faces—peer in from the sidelines, divorced from the pleasures of direct participation, reduced to an audience at the theater of life.

In the late drawings, Picasso sometimes appears before us in drag, just as he occasionally comes to us as Rembrandt or Van Gogh. Equally at home in the masks of the gods and get-ups for the witches' sabbath, he relished metamorphosis. Transposing himself, attaching his person to new identities, he achieved intimate rapport with the many-faced personae of his work. Teeming with characters, the late prints and drawings parade before

us endless opportunities for Picasso's play-acting. One of his greatest roles in the late work is that of the infamous Celestina, the Spanish bawd. Her legendary wickedness is recorded in the late fifteenth-century dramatic novel of the same name, attributed to Fernando de Rojas. Picasso knew her from Spanish folklore. He saw her cockeyed face in Goya. In his youth he even painted a walleyed portrait of her. For all we know, she is present among the *Demoiselles d'Avignon*, just as the madam of Degas' monotypes enjoys the company of her workers, and as Celestina sits with her girls in Goya's *Caprichos*.

In his youth, Picasso was understandably fascinated with this legendary sexual impressaria. Celestina—sharp businesswoman, substitute mother, and witch—ruled over the life of the bordello. In the Spanish classic that bears her name, we hear that she "marred and made up again a hundred thousand maidenheads." She could move rocks if she wanted to and provoke them to lechery. In 1968 Picasso made etchings with Crommelynck for a French edition of *Celestina*; in his old age, Picasso identified in a new way with the picaresque she-devil who describes herself as "past all danger of ravishing." Like the aged painter who brought her to life in pictures, she protests the humiliations of old age, describing herself in a way that can easily apply to the frighteningly vulnerable Vincent-like self-portraits of Picasso's last years: "those deep furrows in the face, that change in the hair, that fading of fresh colour, that want of hearing, weakness of sight, hollowness in the eyes, sinking of the jaws, toothlessness of the gums, feebleness of legs, slowness in feeding . . ." Troublemaker and sex coach (she advises the young to serve multiple partners: "Can one cock fill all cisterns? One conduit water all your court? It goes hard with the mouse that hath but one hole to trust to"), Celestina in old age is also finally reduced to voyeur.

As Picasso grew very old and physically incapable, the character Celestina provided a parallel for his view of himself as an impotent outsider. Much as we may rejoice for having shared the same planet with him, beneficiaries that we are of the brilliance of Picasso's long years, we are made aware at the same time of the painful indignities of old age that he endured and the force he gave to their expression in his last works.

Jeffrey Hoffeld

1. *Danseuse et Femmes*
 June 11, 1960
 Ink and wash on paper
 20 × 25½ in. (50.5 × 65 cm.)
 Signed and dated

 Zervos, XIX, p. 105, no. 345

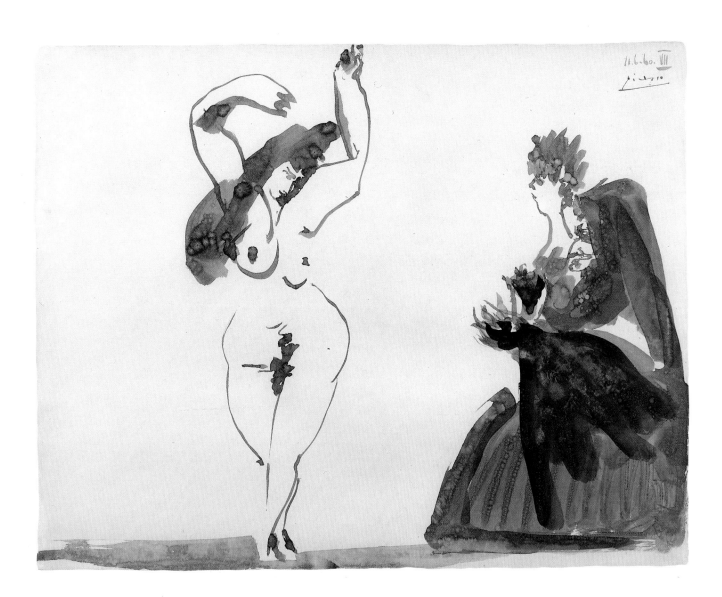

2. *Tête*
 May 26, 1961
 Colored crayon, pastel, and sanguine
 on paper
 10¾ × 8½ in. (27.5 × 21.5 cm.)
 Dated

 Estate of the artist (inventory no. 6440);
 by inheritance to Marina Picasso

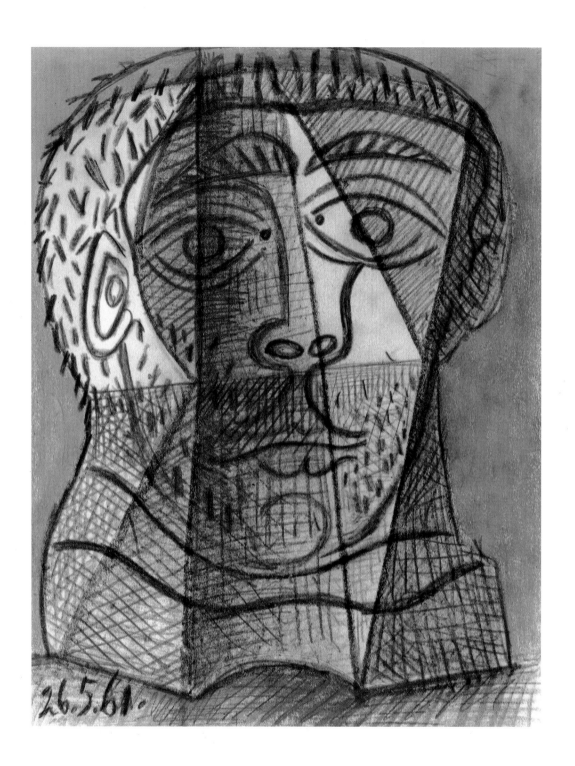

3. *Les Déjeuners*
 July 8, 1961
 Pencil on paper
 10⅝ × 16⅝ in. (27 × 42 cm.)
 Signed and dated

 Zervos, XX, p. 35, no. 66

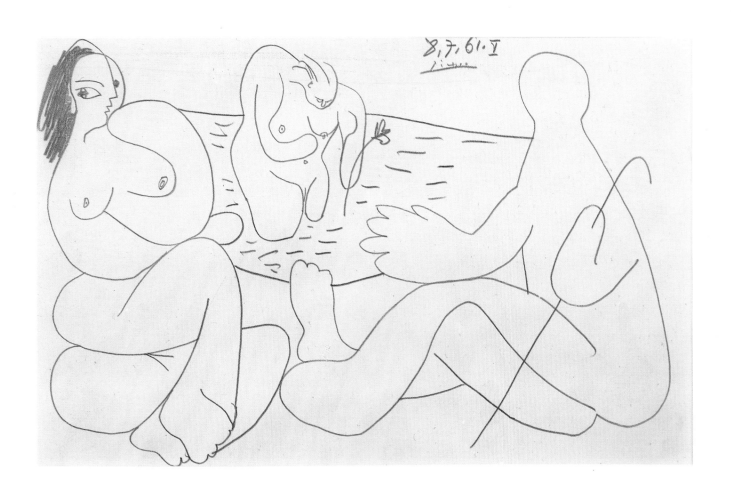

4. *Le Déjeuner*
 June 16, 1962
 Colored crayon and pencil on paper
 14½ × 10½ in. (37 × 26.7 cm.)
 Signed, dated, and inscribed

 Picasso executed this drawing on the title
 page of the book *Picasso: Les Déjeuners*, and
 presented it as a gift to the author, David
 Douglas Duncan. The drawing is signed,
 dated, and inscribed to Duncan, "Pour
 l'ami/D. D. Duncan/Picasso/le 16.6.62."

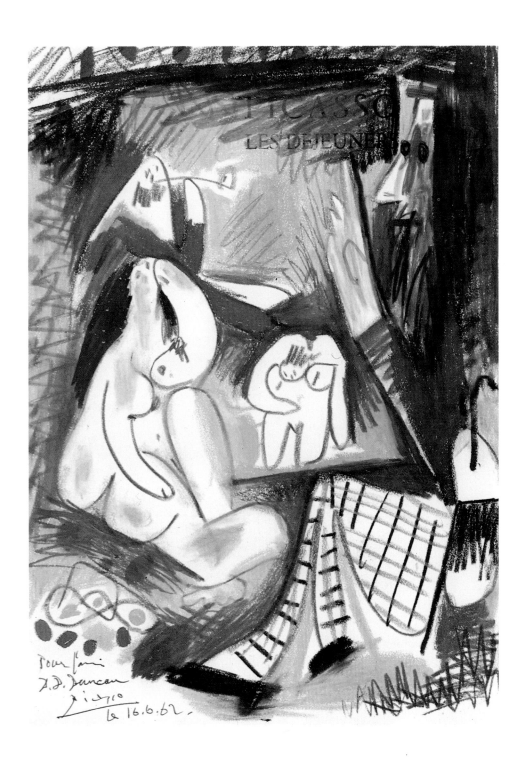

5. *Portrait de Famille*
 October 11, 1962
 Pencil on lithograph
 19⅞ × 25¾ in. (50.5 × 65.5 cm.)
 Dated

 Estate of the artist (inventory no. 6155);
 by inheritance to Marina Picasso

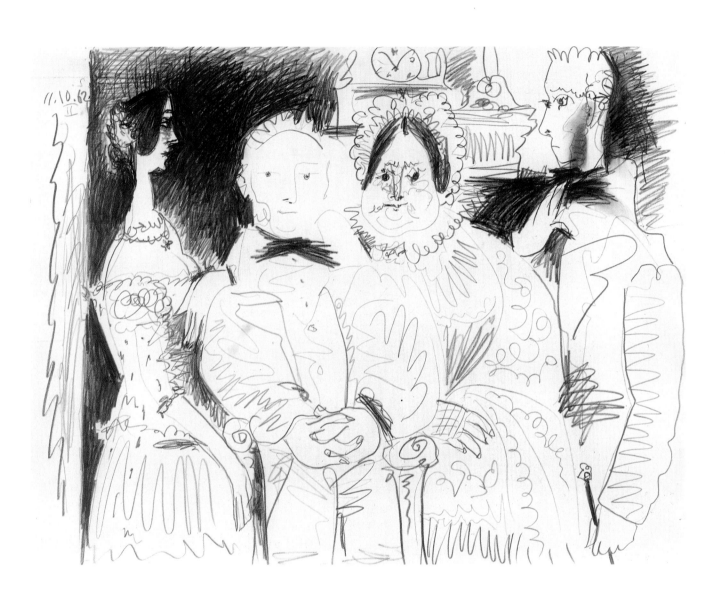

6. *Le Peintre*
 May 18, 1963
 Pencil on paper
 8¾ × 4¼ in. (22.2 × 10.8 cm.)
 Dated

 Zervos, XXIII, p. 125, no. 272

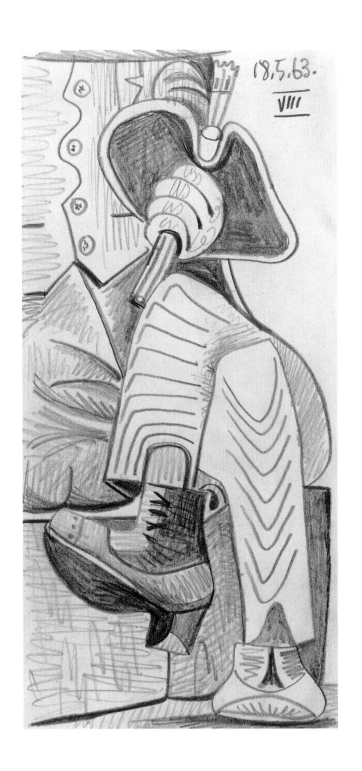

7. *Le Peintre*

 October 17, 1964
 Gouache and ink on reproduction
 38½ × 29½ in. (97.8 × 75 cm.)
 Signed

 Zervos, XXIV, p. 80, no. 226

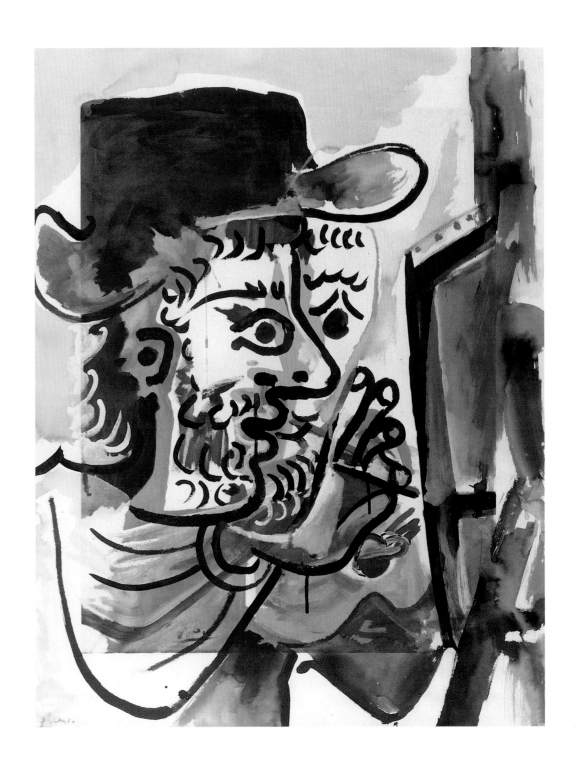

8. *Deux Femmes Nues*
 July 3, 1966; October 5, 1966
 Colored crayon and gouache on paper
 19¾ × 24 in. (50 × 61 cm.)
 Dated

 Estate of the artist (inventory no. 6269);
 by inheritance to Marina Picasso

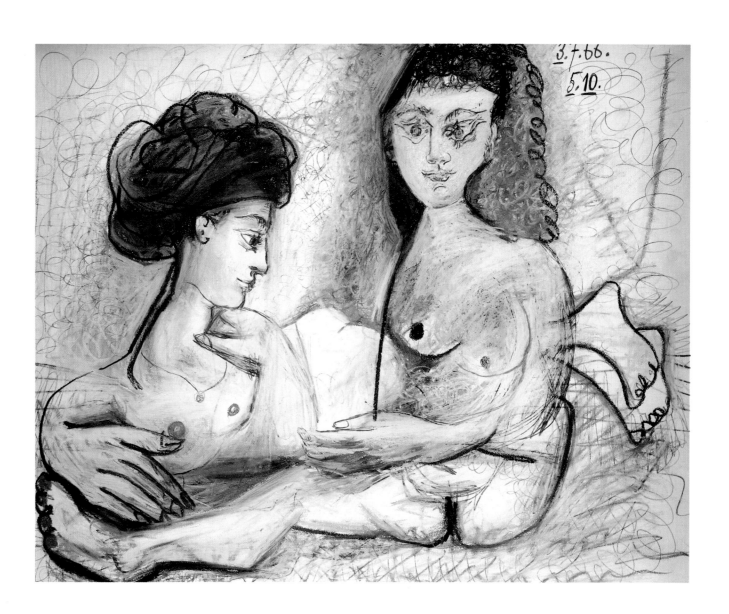

9. *Personnages et Profil*
 February 9, 1967
 Ink and wash on paper
 20¼ × 25¼ in. (51.5 × 64 cm.)
 Signed and dated

 Zervos, XXV, p. 124, no. 271

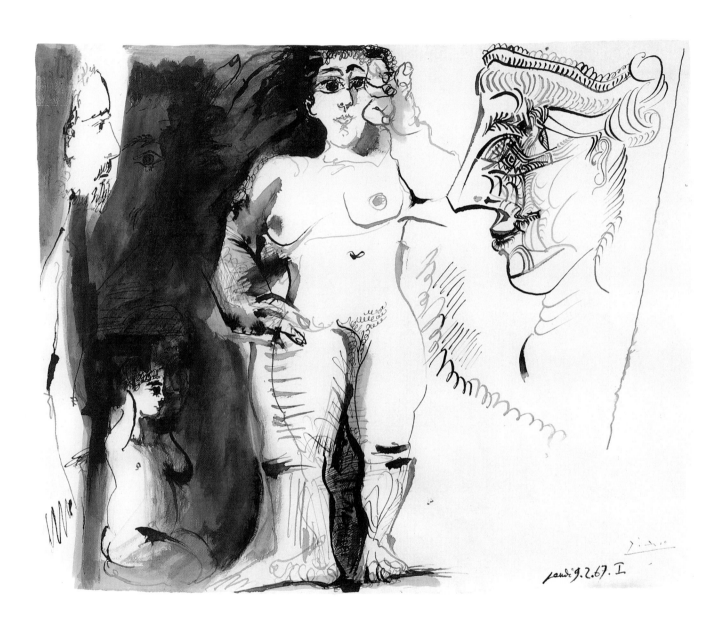

10. *Homme au Mouton et Flutiste*
 February 9, 1967
 Ink and wash on paper
 19½ × 25½ in. (49.5 × 64.7 cm.)
 Signed and dated

 Zervos, XXV, p. 124, no. 273

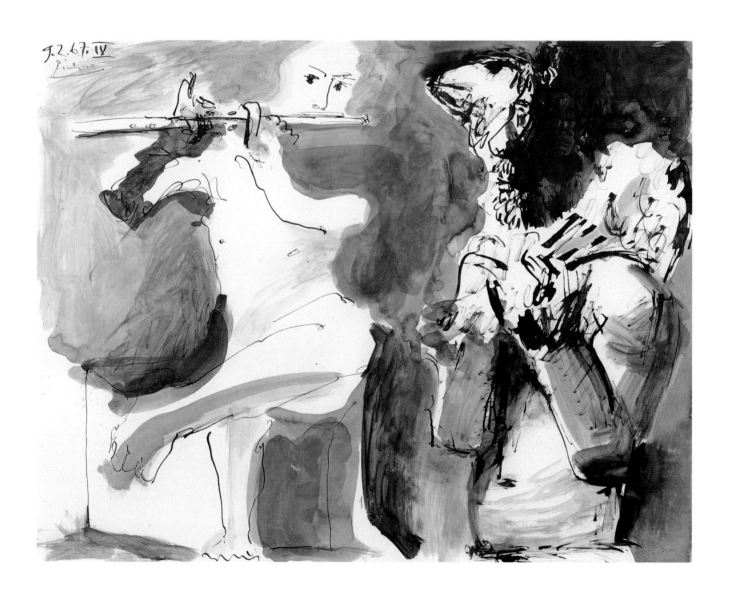

11. *Tête de Mousquetaire à la Pipe*
 February 10, 1967
 Ink and wash on paper
 25½ × 19¾ in. (64.7 × 50 cm.)
 Signed and dated

 Zervos, XXVII, p. 180, no. 452

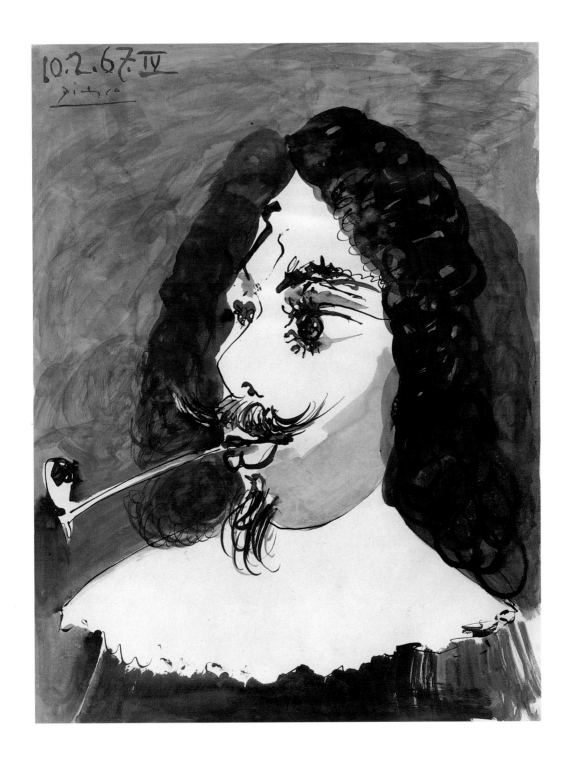

12. *Aigle et Personnages*
March 10, 1967
Ink and wash on paper
19½ × 29¾ in. (49.5 × 75.5 cm.)
Signed and dated

Zervos, XXV, p. 128, no. 289

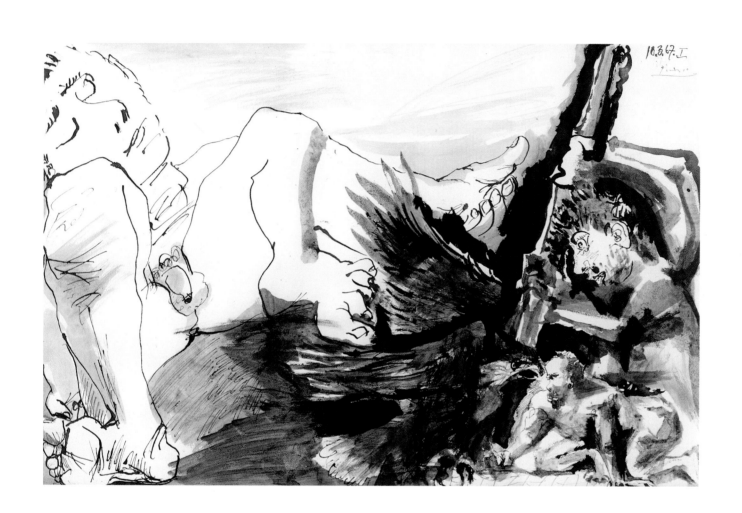

13. *Trois Personnages*
 June 5, 1967; June 7, 1967
 Ink and wash on paper
 19½ × 24 in. (49.5 × 61 cm.)
 Signed and dated

 Zervos, XXVII, p. 185, no. 489

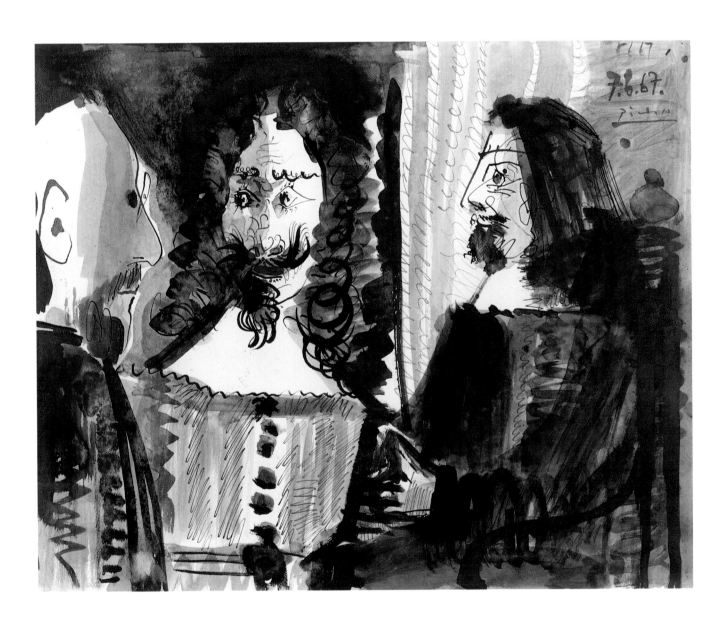

14. *Figures*
 July 4, 1967
 Ink and wash on paper
 14½ × 20⅝ in. (36.8 × 52.5 cm.)
 Signed and dated

 Zervos, XXVII, p. 16, no. 53

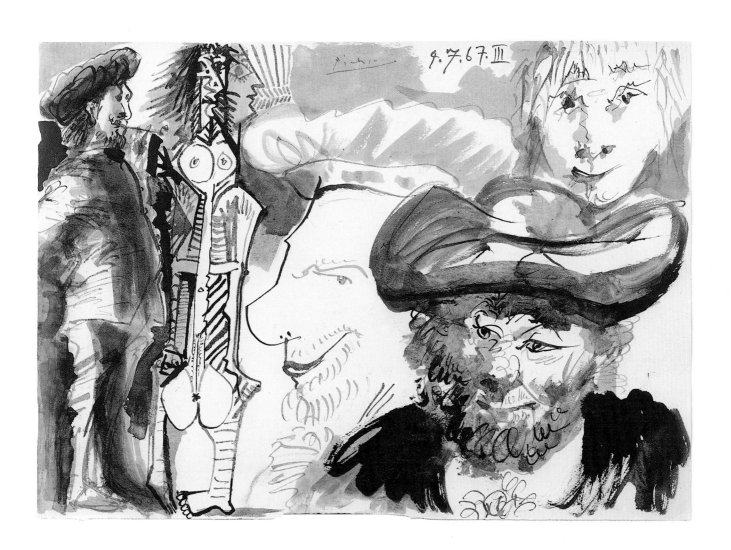

15. *Femme Nue Allongée* (verso of no. 14)
 July 4, 1967
 Ink and wash on paper
 14½ × 20⅝ in. (36.8 × 52.5 cm.)
 Signed and dated

 Zervos, XXVII, p. 16, no. 52

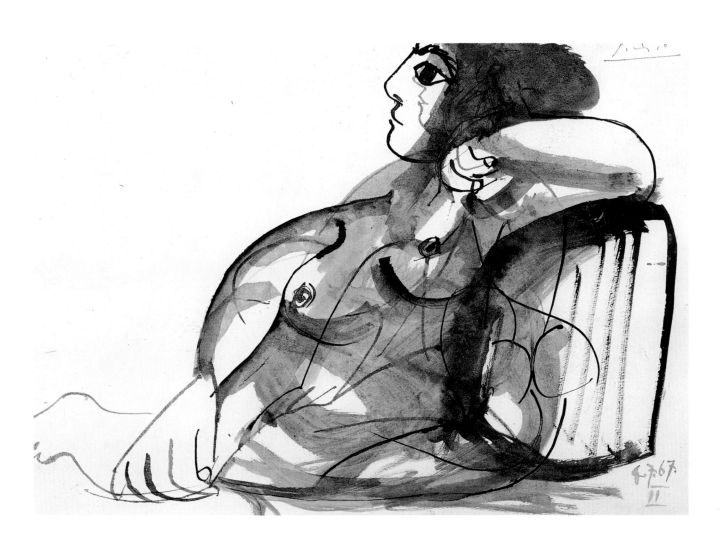

16. *Quatre Personnages Nus*
 September 25, 1967
 Ink and wash on paper
 22¼ × 29½ in. (56.5 × 75 cm.)
 Signed and dated

 Zervos, XXVII, p. 36, no. 124

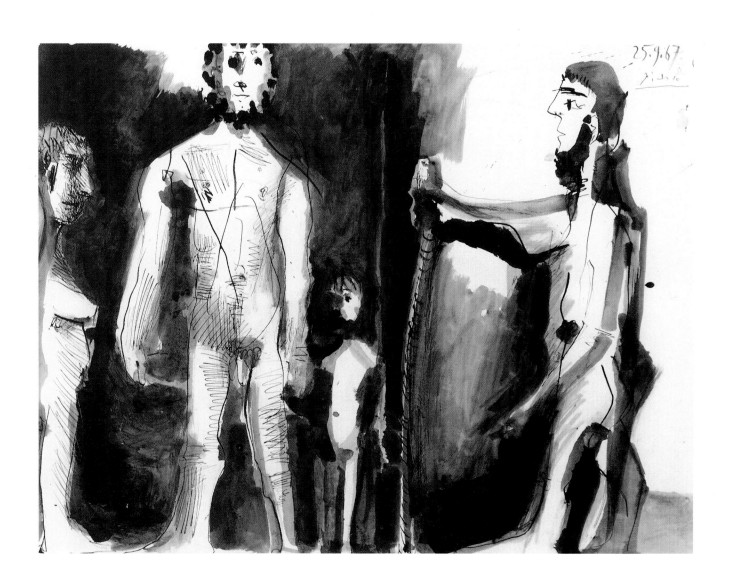

17. *Le Baiser*

October 7, 1967

Pencil on paper

19⅞ × 25¾ in. (50.5 × 65.5 cm.)

Signed and dated

Zervos, XXVII, p. 40, no. 133

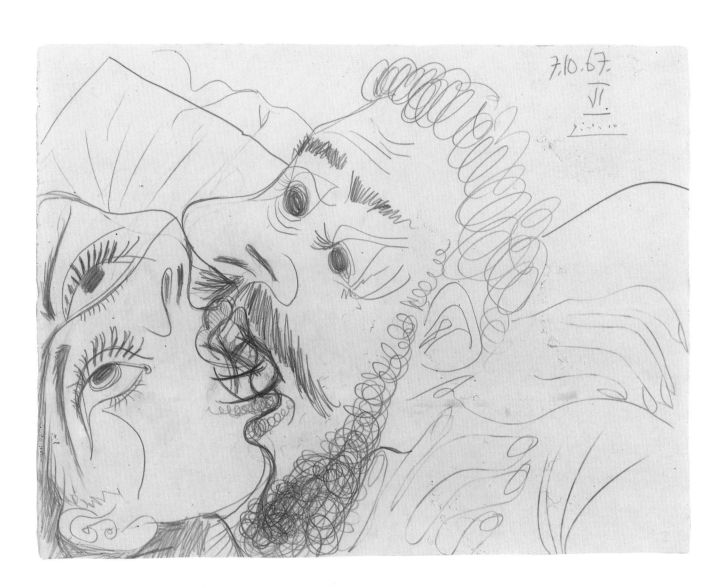

18. *Hommes et Femmes Nus*
 November 8, 1967; November 11, 1967;
 December 25, 1967
 Ink, wash, and gouache on paper
 25½ × 22⅞ in. (64.7 × 58 cm.)
 Signed and dated

 Zervos, XXVII, p. 57, no. 168

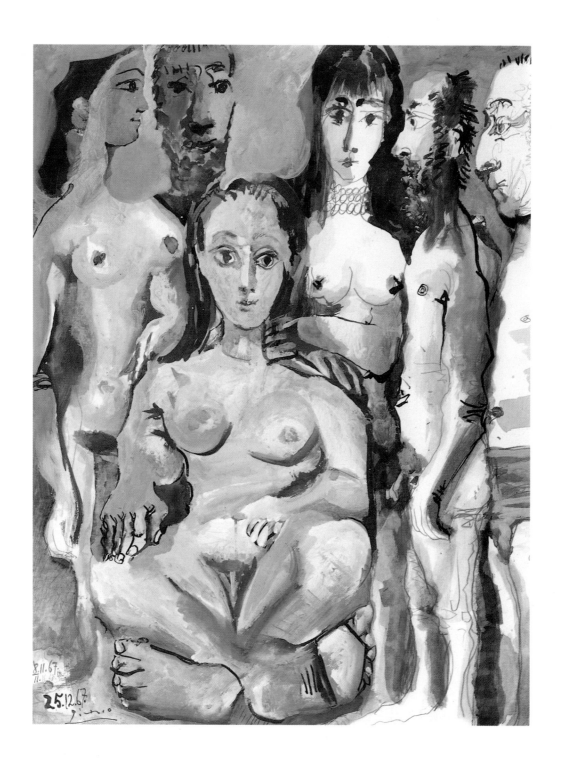

19. *Le Bain*
 February 16, 1968
 Pencil on paper
 18¾ × 23 in. (47.5 × 58.5 cm.)
 Signed and dated

 Zervos, XXVII, p. 91, no. 231

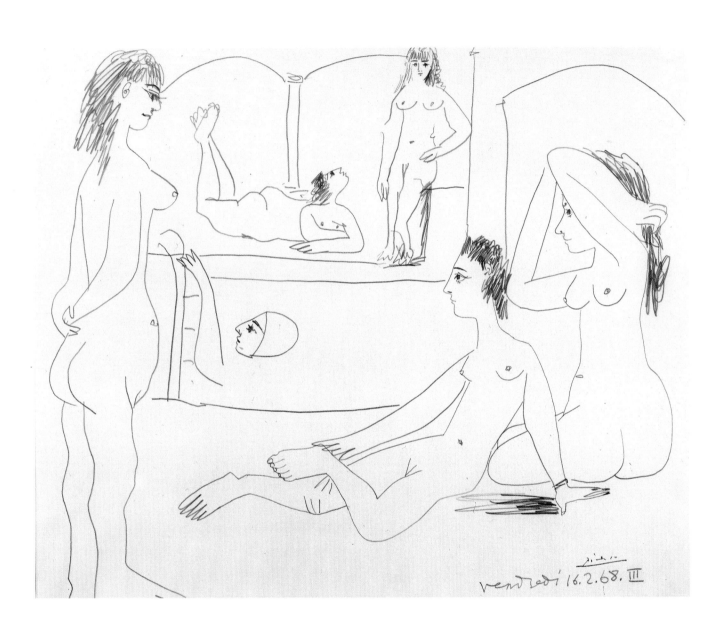

vendredi 16.2.68. III

20. *L'Étreinte*
 September 10, 1968
 Colored crayon on paper
 19½ × 25½ in. (49.5 × 64.7 cm.)
 Signed and dated

 Zervos, XXVII, p. 115, no. 294

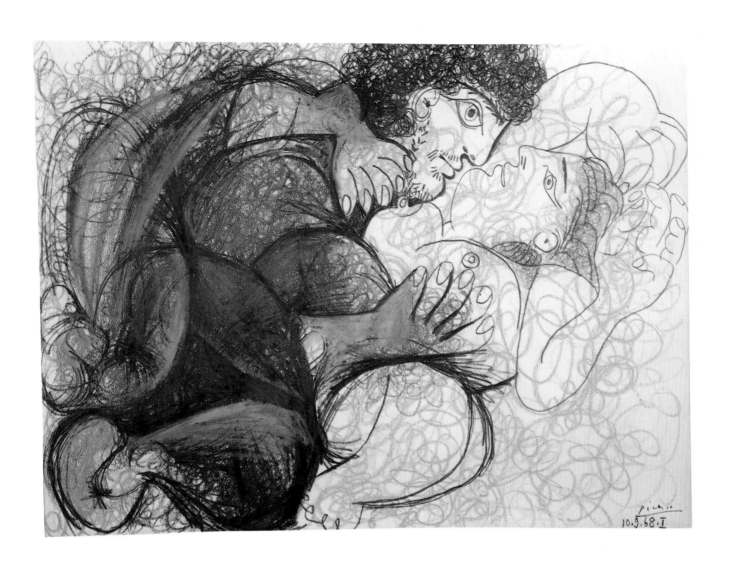

21. *Quatre Personnages*
 October 2, 1968
 Ink and wash on paper
 19¾ × 25¾ in. (50 × 65.5 cm.)
 Signed and dated

 Zervos, XXVII, p. 122, no. 318

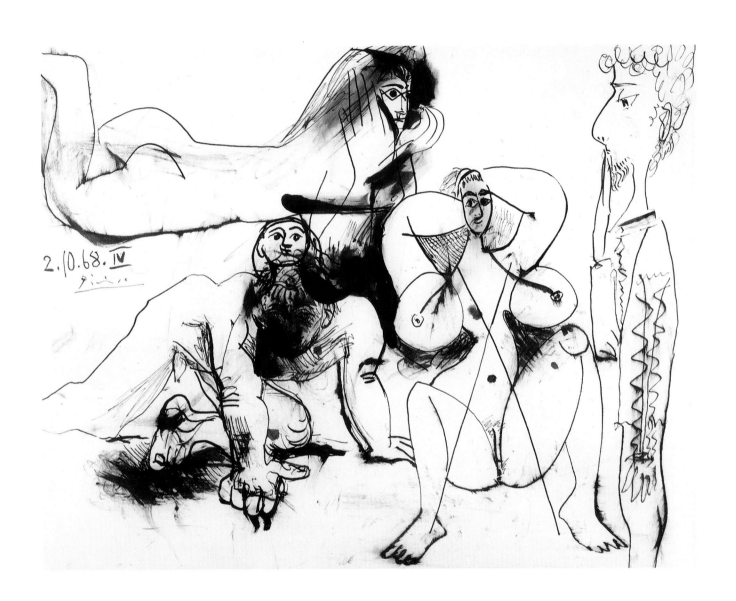

22. *Homme au Turban et Nu Couché*
 August 26, 1969
 Pencil on paper
 19¾ × 25¾ in. (50 × 65.5 cm.)
 Signed and dated

 Zervos, XXXI, p. 113, no. 393

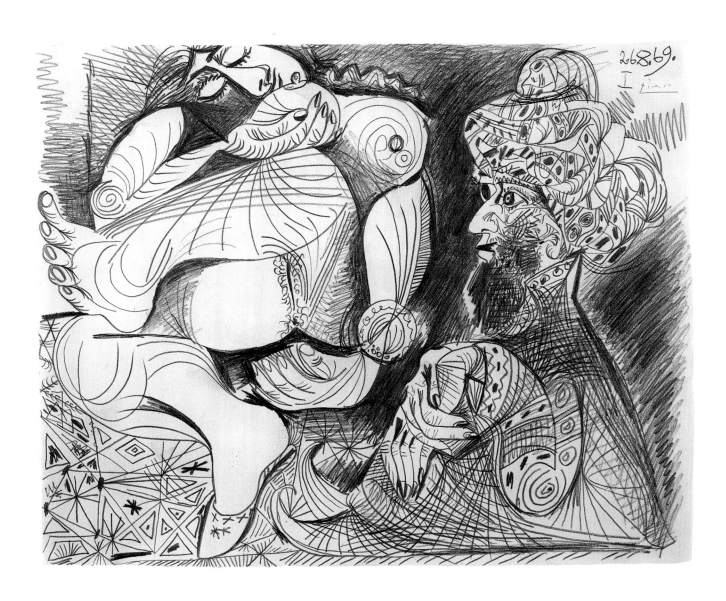

23. *Nu Couché*
 September 1, 1969
 Colored crayon on paper
 19⅞ × 25½ in. (50.5 × 64.7 cm.)
 Dated

 Zervos, XXXI, p. 115, no. 403

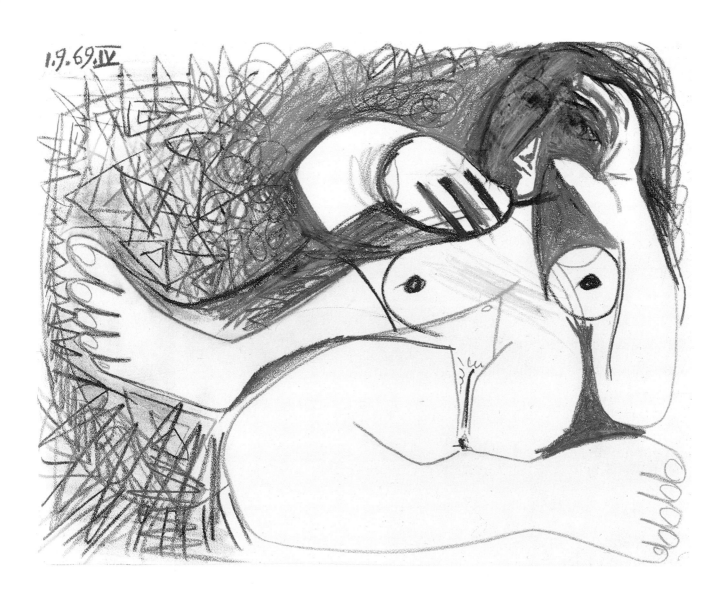

24. *Deux Femmes Assises*
September 19, 1969
Pencil on paper
18¾ × 24 in. (47.5 × 61 cm.)
Signed and dated

Zervos, XXXI, p. 126, no. 435

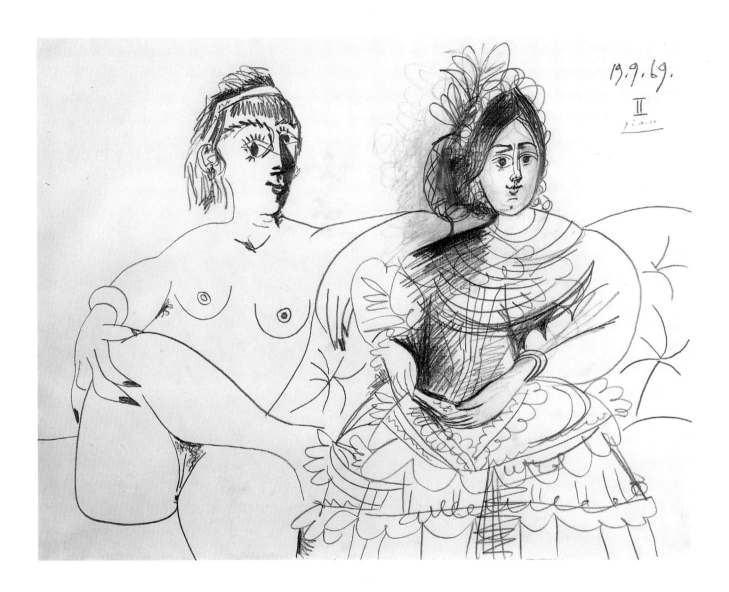

25. *Le Peintre et son Modèle*
 May 24, 1970
 Pen and ink on paper
 7 × 10 in. (17.7 × 25.4 cm.)
 Signed and dated

 Zervos, XXXII, p. 37, no. 83

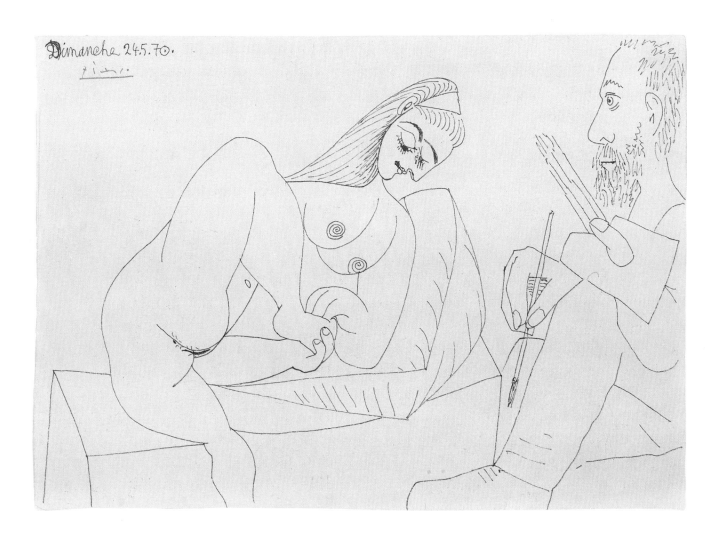

26. *Homme et Femme Nus*
 August 2, 1970
 Pencil on paper
 13 × 19¾ in. (33 × 50 cm.)
 Signed and dated

 Zervos, XXXII, p. 79, no. 248

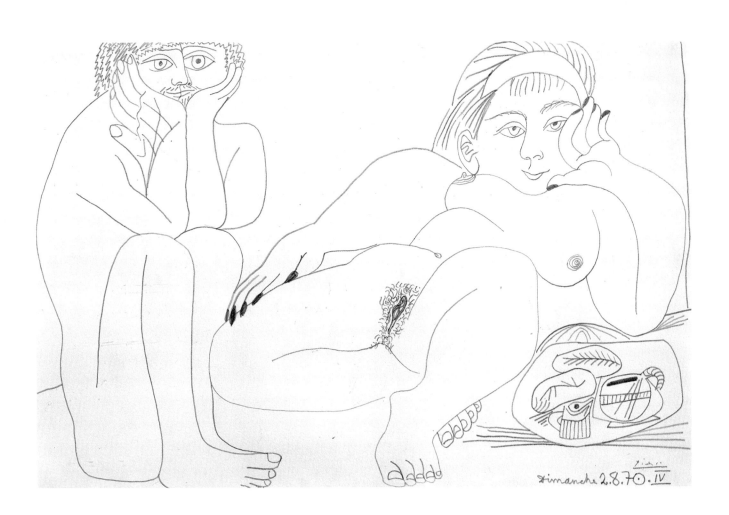

Dimanche 2.8.70. IV

27. *Tête*

September 7, 1971
Colored crayon and pencil on cardboard
12½ × 9¼ in. (31.7 × 23.5 cm.)
Signed and dated

Zervos, XXXIII, p. 64, no. 176

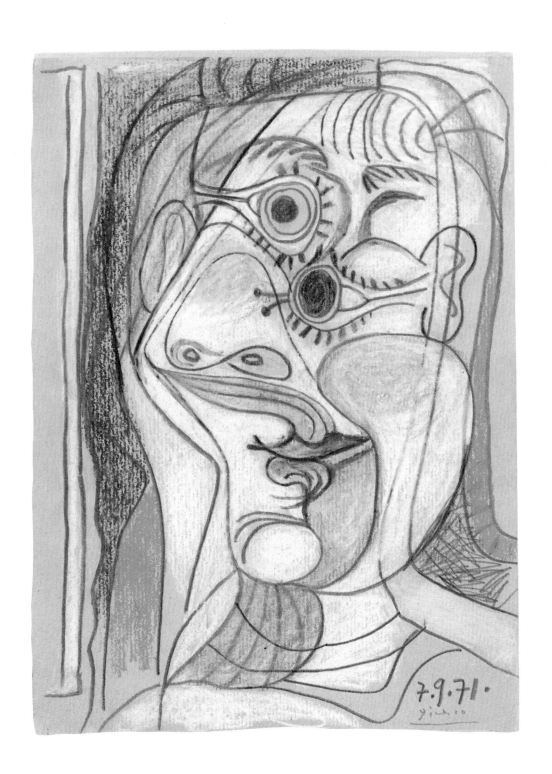

28. *Tête*

September 26, 1971

Colored crayon on cardboard

13¼ × 9¼ in. (33.5 × 23.5 cm.)

Recto signed and dated; verso dated

Zervos, XXXIII, p. 71, nos. 200, 201

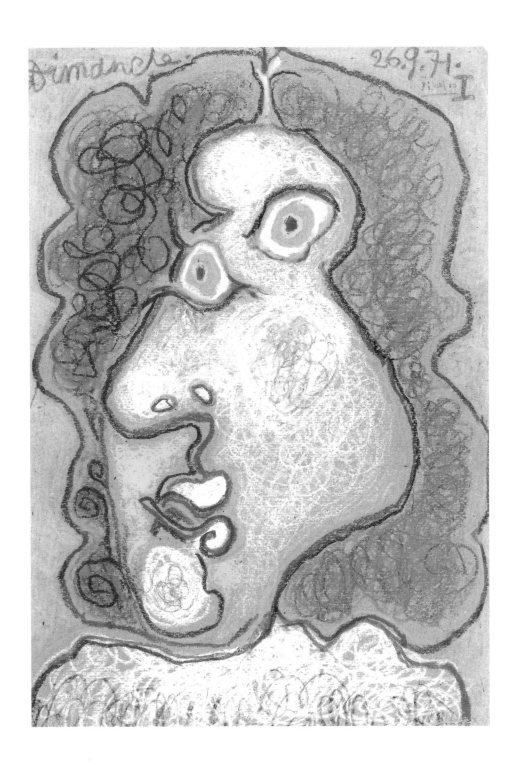

29. *Quatre Nus à l'Oiseau*
 November 21, 1971
 Pen and ink on paper
 19¾ × 25½ in. (50 × 64.7 cm.)
 Signed and dated

 Zervos, XXXIII, p. 82, no. 235

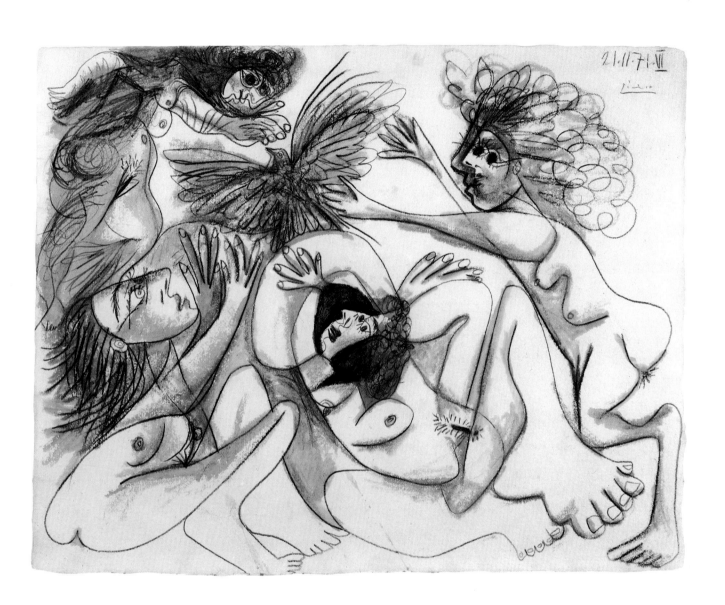

30. *Deux Nus*
 November 21, 1971
 Ink, pencil, and colored crayon on paper
 19⅞ × 25⅜ in. (50.5 × 64.5 cm.)
 Dated

 Zervos, XXXIII, p. 82, no. 236

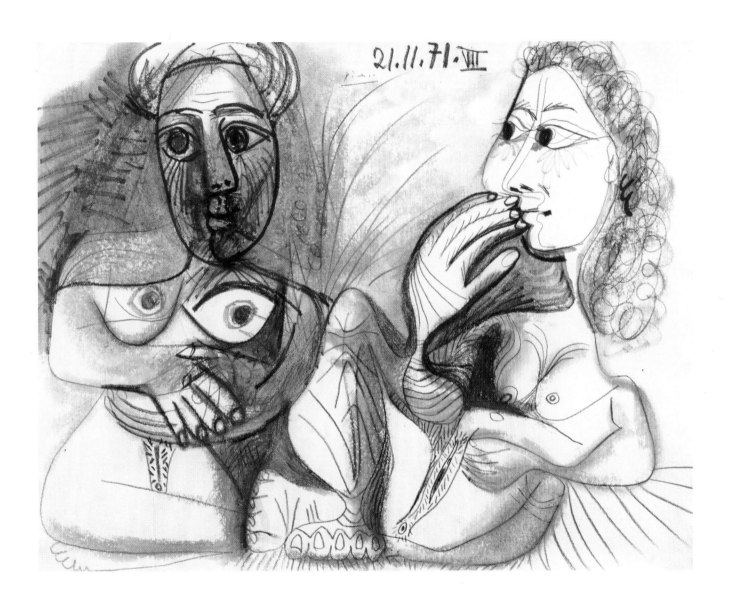

31. *Nu*

November 23, 1971
Colored crayon and pencil on paper
19¾ × 25¼ in. (50 × 64 cm.)
Signed and dated

Zervos, XXXIII, p. 82, no. 237

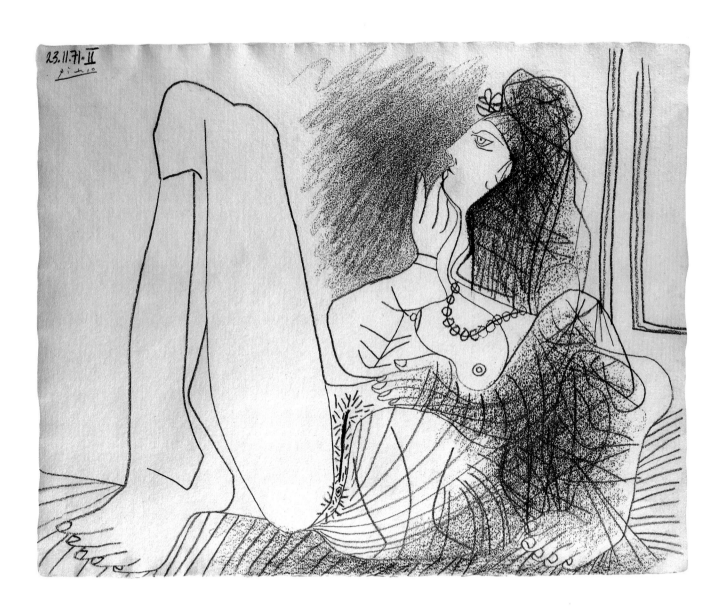

BIBLIOGRAPHY

Alberti, Rafael. *Picasso en Avignon. Commentaires à une peinture en mouvement.* Paris: Éditions Cercle d'Art, 1971.

Alberti, Rafael. *Picasso, le rayon ininterrompu.* Paris: Éditions Cercle d'Art, 1974.

Ashton, Dore. *Picasso on Art: A Selection of Views.* New York: Viking Press, 1972.

Bloch, Georges. *Catalogue de l'oeuvre gravé et lithographié*, Vols. I, II, and IV. Berne: Kornfeld et Cie, 1968, 1971, 1979.

Boggs, Jean Sutherland. "The Last Thirty Years." In *Picasso in Retrospect*, edited by Sir Roland Penrose and Dr. John Golding, pp. 11–47. New York: Praeger, 1973.

Brassaï. *Conversations avec Picasso.* Paris: Gallimard, 1964.

Cabanne, Pierre. *Le Siècle de Picasso*, 4 vols. Paris: Éditions Denoël, 1975.

Cohen, Janie L. "Picasso's Exploration of Rembrandt's Art." In *Arts Magazine*, Vol. LVIII, No. 2 (October 1983), pp. 119–126.

Cooper, Douglas. *Degas: Monotypes, Drawings, Pastels, Bronzes.* London: The Lefevre Gallery, 1958.

Cristea, Alan, and Gilmour, Pat. *Aldo Crommelynck, in Collaboration with Georges Braque, Pablo Picasso, Richard Hamilton, Jim Dine.* London: Waddington Graphics, 1987.

Daix, Pierre. *Picasso Créateur: La Vie Intime et l'Oeuvre.* Paris: Éditions du Seuil, 1987.

Gallwitz, Klaus. "Zum Spätwerk Picassos." In *Pablo Picasso. Eine Ausstellung zum hundertsten Geburtstag, Werke aus der Sammlung Marina Picasso.* Haus der Kunst, München; Köln; Frankfurt am Main; Zürich, 1981–82.

Geelhaar, Christian. "Themen 1964–1972." In *Pablo Picasso: Das Spätwerk—Themen 1964–1972.* Basel: Kunstmuseum, 1981.

Häsli, Richard. "Zu zwei Altersradierungen von Picasso." In *Pablo Picasso: Das Spätwerk—Themen 1964–1972.* Basel: Kunstmuseum, 1981.

Kelly, Laurence, ed. *Istanbul, A Traveller's Companion.* London: Constable and Company Ltd., 1987.

Mellow, James R. "Picasso: The Artist in His Studio." In *Picasso: The Avignon Paintings.* New York: The Pace Gallery, 1981.

Parmelin, Hélène. *Les Dames de Mougins.* Paris: Éditions Cercle d'Art, 1964.

Parmelin, Hélène. *Picasso Dit* Paris: Éditions Gonthier, 1966.

Penrose, Roland. *Picasso, His Life and Work.* London: Paladin, 1981.

Pérez-Sanchez, Alfonso. *Goya: Caprichos-Desastres-Tauromaquia-Disparates.* Madrid: Fundación Juan March, 1979.

Quinn, Edward, and Daix, Pierre. *The Private Picasso*. Boston: Little, Brown, and Company, and New York Graphic Society, 1987.

Reff, Theodore. "Themes of Love and Death in Picasso's Early Work." In *Picasso in Retrospect*, edited by Sir Roland Penrose and Dr. John Golding, pp. 11–47. New York: Praeger, 1973.

Richardson, John. "Picasso's Apocalyptic Whorehouse." In *The New York Review of Books*, Vol. XXXIV, No. 7 (April 23, 1987), pp. 40–47.

De Rojas, Fernando. *Celestina*, translated by James Mabbe and Eric Bentley. New York: Applause, 1986.

Rubin, William, ed. *Pablo Picasso: A Retrospective*. New York: The Museum of Modern Art, 1980.

Rubin, William, and Esterow, Milton. "Visits with Picasso at Mougins." In *Art News*, Vol. LXXII, No. 6 (Summer 1973), pp. 42–46.

Russell, John. "Art Born in the Fullness of Age." In *The New York Times*, Sunday, August 23, 1987, section 2, pp. 1, 22.

Schiff, Gert, ed. *Picasso in Perspective*. Englewood Cliffs, N.J.: Prentice-Hall, 1976.

Schiff, Gert. "Picasso's Old Age: 1963–1973." In *Art Journal*, Vol. XLVI, No. 2 (Summer 1987), pp. 122–126.

Schiff, Gert. *Picasso, The Last Years, 1963–1973*. New York: Solomon R. Guggenheim Museum; Grey Art Gallery and Study Center, New York University, 1983.

Snell, Bruno. *The Discovery of the Mind in Greek Philosophy and Literature*. New York: Dover, 1982.

Sollers, Philippe, and Kirili, Alain. *Rodin: Dessins érotiques*. Paris: Gallimard, 1987.

Spies, Werner. *Picasso: Pastelle, Zeichnungen, Acquarelle*. Stuttgart: Hatje, 1986.

Steinberg, Leo. "The Algerian Women and Picasso at Large." In *Other Criteria: Confrontations with Twentieth-Century Art*, by Leo Steinberg, pp. 125–234. New York: Oxford University Press, 1972.

PICASSO
THE LATE DRAWINGS

Designed by Marcus Ratliff, Inc.
Photographs by Helga Studio
Photocomposed by Trufont Typographers
in Linotype Walbaum

Printed by Daniel Skira & Partners
Geneva, Switzerland